ANGEL BABIES II

ZYXVEN

THE SANCTUARY OF HAVEN

Angel Babies II

ZYXVEN

THE SANCTUARY OF HAVEN

~*~

Clive Alando Taylor

authorHOUSE®

AuthorHouse™
1663 Liberty Drive
Bloomington, IN 47403
www.authorhouse.com
Phone: 1-800-839-8640

Published by AuthorHouse 04/05/2013

ISBN: 978-1-4817-8013-1 (sc)
ISBN: 978-1-4817-8014-8 (e)

~*~

It was very much my intention not to state the name of any particular place in the script as I thought that the telling of the story of the Angel Babies is in itself about believing in who you are, and also about facing up to your fears. The Angel Babies is also set loosely in accordance with the foretelling of the Bibles Revelations.

I thought it would be best to take this approach, as the writing of the script is also about the Who, What, Where, When, How and Why scenario that we all often deal with in our ongoing existence. It would also not be fair to myself or to anyone else who has read the Angel Babies to not acknowledge this line of questioning, for instance, who are we? What are we doing here? Where did we come from? And when will our true purpose be known? And how do we fulfil our true potential to better ourselves and others, the point of which are the statements that I am also making in the Angel Babies and about Angels in particular,

Is that if we reach far into our minds we still wonder Where did the Angels come from and what is their place in this world. I know sometimes that we all wish and pray for the miracle of life to reveal itself but the answer to this mystery truly lives within us and around us, I only hope that you will find the Angel Babies an interesting narrative and exciting story as I have had in bringing it to life, after all there could be an Angel Baby being born right now.

~*~

INTRODUCTION

Because of the things that have first become proclaimed within the spirit, and then translated in the soul, in order for the body to then become alive and responsive or to aspire or to be inspired, if only then for the body to become a vessel, or a catalyst or an instrument of will, with which first the living spirit that gave life to it, along with the merits and the meaning of life, and the instruction and the interpretation of life, is simply to understand that the relationship between the spirit and the soul, are also the one living embodiment with which all things are one, and become connected and interwoven by creating or causing what we can come to call or refer to as the essence or the cradle or the fabric of life, which is in itself part physical and part spirit.

And so it is with this power that we are all brought into being, along with this primordial spiritual birth, and along with this the presence or the origins of the spirit, which is also the fabric and the nurturer of the soul with which the body can be formed, albeit that by human standards, this act of nature however natural, can now take place through the act of procreation or consummation, and so it is with regard to this living spirit that we are also upon our natural and physical birth, given a name and a number, inasmuch that we represent or become identified by a color, or upon our created formation and distinction of identity, that we become recognized by our merits and individuality.

But concerning the Angels it has always been of an interest to me how their very conception or existence or origin from nature and imagination could have become formed and brought into being, as overtime I have heard several stories of how with the event of the first creation of man, that upon this event, that all the Angels were made to accept and to serve in God's creation of man, and that man was permitted to give command to these Angels in the event of his life and the trials of his life which were to mastered within this godly decree and narrative, where we also see there was all but one Angel that either disagreed or disapproved with not only the creation of man, but also with the formation of this covenant between God and man, and that all but one Angel was Satan, who was somewhat displeased with God's creation of man, and in by doing so would not succumb or show respect or demonstrate servility or humility toward man or mankind.

As overtime it was also revealed to me that with the creation of the Angels, that it was also much to their advantage as it was to ours, for the Angels themselves to adhere to this role and to serve in the best interest of man's endeavors upon the face of the earth, as long as man himself could demonstrate and become of a will and a nature to practice his faith with a spirit, and a soul, and a body that would become attuned to a godly or godlike nature, and in by doing so, and in by believing so, that all of his needs would be met with accordingly.

And so this perspective brings me to question my own faith and ideas about the concept and the ideology of Angels, insomuch so that I needed to address and to explore my own minds revelation and to investigate that which I was told or at least that which I thought I knew concerning the Angels along with the juxtaposition that if Satan along with those Angels opposed to serving God's creation of man, and of those that did indeed seek to serve and to favor God's creation and, to meet with the intentions, and the merits, and the dreams, and the aspirations of man that could indeed cause us all to be at the mercy and the subjection of an externally influential and internal spiritual struggle or spiritual warfare, not only with ourselves, but also with our primordial and spiritual identity and place of origin.

And also because of our own conceptual reasoning and comprehension beyond this event, is that we almost find ourselves astonished into believing that this idea of rights over our mortal souls or being, must have begun or started long ago, or at least long before any of us were even souls inhabiting our physical bodies here as a living presence upon the face of the earth, and such is this constructed dilemma behind our beliefs or identities, or the fact that the names or the numbers that we have all been given or that have at least become assigned to us, is simply because of the fact that we have all been born into the physical world.

As even I in my attempts to try to come to terms with the very idea of how nature and creation could allow so many of us to question this reason of totality if only for me to present to you the story of the Angel babies, if only to understand, and to restore your faith, and your belief along with mine back into the realms of mankind and humanity, as I have also come to reflect in my own approach and understanding of this narrative between God and Satan and the Angels, that also in recognizing that they all have the power to influence and to subject us, as well as to direct mankind and humanity either to our best or worst possibilities, if only then to challenge our primordial spiritual origin within the confines of our own lifestyles and practices and beliefs, as if in our own efforts and practices, that we are all each and every one of us, in subjection or at least examples and products of both good and bad influences.

Which is also why that in our spiritual nature we often call out to these heavenly and external Angelic forces to approach us, and to heal us, and to bless us spiritually, which is, or has to be made to become a necessity, especially when there is a humane need for us to call out for their assistance and the welfare and the benefit of our souls and our bodies to be aided or administered too, or indeed for the proper gifts to be bestowed upon us and to empower us in such a way that we can receive guidance and make affirmations through the proper will and conduct of a satisfactory lesson learnt albeit through this practical application and understanding if only to attain spiritual and fruitful lives.

As it is simply by recognizing that we are or at some time or another in our lives, have always been open or subject to the interpretations of spiritual warfare by reason of definition, in that Satan's interpretation of God's creation is something somewhat of contempt, in that God should do away with or even destroy creation, but as much as Satan can only prove to tempt or to provoke God into this reckoning, it is only simply by inadvertently influencing the concepts or the ideologies of man is also to say that the fact that God has also created man to be creators, and Satan in realizing this, that man through his trials of life could also be redeemed and deemed to be seen in Satan's view as unworthy of creation, in that God had somehow failed in this act of creation, and that Satan who I might hasten to add is also just an Angel, could somehow convince God of ending creation, as Satan himself cannot nor does not possess the power to stop or to end creation, which of course is only in the hands of God the creator.

And so this brings me back to the Angels, and of those that are in favor of either serving or saving mankind from his own end and destruction, albeit that we are caught up in a primordial spiritual fight, that we are all engaged in, or by reason of definition born into, and so it is only by our choices that we ultimately pay for our sacrifice or our rights to life, inasmuch that we are all lifted up to our greatest effort or design, if we can learn to demonstrate and to accept our humanity in a way that regards and reflects our greater desire or need to be something more than what we choose to believe is only in the hands of God or indeed a spirit in the sky.

Angel Babies II
ZyxvenThe Sanctuary Of Haven

~*~

Time is neither here or there, it is a time in between time as it is the beginning and yet the end of time. This is a story of the Alpha and the Omega, the first and the last and yet as we enter into this revelation, we begin to witness the birth of the Angel Babies a time of heavenly conception when dying Angels gave birth to Angelic children who were born to represent the order of the new world. The names of these Angel Babies remained unknown but they carried the Seal of their fathers written on their foreheads, and in all it totalled one hundred and forty four thousand Angels and this is the story of one of them.

~*~

INSPIRIT*ASPIRE*ESPRIT*INSPIRE

My name is Haven, and I was one born, one of the last if not the least of Angels amidst the latter part of the new millennium to my Earth Mother Mercidiah, who from time to time I would watch over her cautiously from afar, and to also make sure that she would come to no harm, and to make sure that she somehow felt protected by my spiritual and omnipotent presence and inner spirit, bestowed upon me by my immortal and sentient Angelic father Simeon, who had by now ascended into the first becoming of the several worlds high above the realms of the Empyreans', not much long after the decree and the proclamation that had been and become prophesied long ago, and brought into being and effect and to bear as a declaration of infinite totality concerning the whole of life, and more importantly, the inhabitants of the Earth.

As I have had very little contact with the Earth, and with the inhabitants and the life that it contains and sustains, and so I am very much at a disposition and disadvantage to give a clear or observational insight as to what would or could change, or indeed help to influence and navigate this Earthly paradox into a new dimension, that may help to serve or at least have a lasting impact upon the mysterious forces that give way to inspire and influence mankind in such a way so as to hasten our spiritual enlightenment and awaken our spiritual growth, and to help unhinder and uninhibit our perception of the first becoming of the several worlds that binds and bounds us all together in this the Emerald dream, that keeps us all within a Unitarian perspective and harmony, with all that is and with all that was before us.

Although deep down within the love of my heart, there remains in me such a grave fear of anguish, and torment, the even one such as I, am reluctant to look deeper and further into the dreaded abyss of my own prism, if only to see that the many arrays and expanse upon reflection could not change or prevent the imaginings of my own will and despair, that one day that all that is, could simply without shape or form, or without reason or definition disappear or vanish from the face of this vast if not infinite reality that we all perceive or have at least come to know and accept as the present and eternal reality, which governs even the most remoteness and simplest of life forms, that have shaped and adapted to this world within.

And such was my fear and anguish, that I sought to turn away from the prism in my mind, if only momentarily to at least appeal to my senses, to reveal to me and to show to me a better if not refined set of principles based upon these moral if not judgmental revelations, that only I could have deduced from and given depth and clarity of meaning too, but as for now I have realized that only too well that time would and could not yield to me the answer with which I could face and base any of my preoccupied findings and self discovery upon consisting of both an absent and mystical knowledge with which I could base any of my own imaginings upon.

Coupled with the fact that if there were any basis for me to address my fear with head on impact, so as to dissipate, and abate, and distinguish any further tormented reasoning, that could so easily arise out of the vast matter of nothing more, other than the idea that a mere mistake could account for, or otherwise throw me and the Emerald dream into chaos, and of course as it was duly noted, that this lapsing and haphazard confusing concoction of space, and gravity, and time, had already begun even since the world had entered into this horrendous consequence and scientific age and phase of men, but as for me this was only a primitive and primordial event and element, which was only by now into the eleventh year of its' infancy, as we had not yet and for so long, entered into the new millennia.

And all the while I was anxious and in a mood and a motion of instability not knowing if or when my inquisition would come to pass, or that with my being ever so remote and in seclusion of the master plan that should and would prevail could indeed succeed in life the way that it had been explained and revealed to mankind in the way that it had been decreed and proclaimed in the Empyrean's of the heavens, and such was my not knowing the full outcome of my destiny or fate, or how my trial should be directed and organized, and tutored and tailored to examine, and if need be, to be reexamined if necessary, so as to detail and to explain and to outline or even instruct all the intricate facets and aspects or possible results and outcomes, that I may give witness or rise too, in my account and testimony of my constituent part and role within this the Emerald dream

And so now I have become so much more reluctant and despondent to find the will to gravitate toward a wider lesson now to be realized in my new found freedom and reality, that once upon an aeon ago which gave way and rise to the Golden ages of life's inventions, if not only to record history and time itself, and so it is with this idea that I now choose to address within you this aeon, to speculatively address that the time of man may only be told by the events that he himself alone chooses to record and navigate towards too in his own history and narrative, based upon wildly narrowing biased conjecture with a saturating appetite for vanity, and lust, and destruction, filled with an apathy of supposition after supposition, even after realizing that his history is a story yet to be told or to unfold like these steps that lead us to the pearly gates of heaven that he alone chooses to fantasize with.

And so now let me come forward, to pronounce, and to announce to one and all, that even beyond these supposed gates of heaven, or even unto this glorification of eternal well being, and the sanctity of an enduring everlasting after life of immortality, that somehow and in some way, that there is still a remote and sanctified place amongst the stars upon which no one can envisage, or truly comprehend exactly how near, or how far we are from one another, as even within this the first becoming of the several heavenly worlds, that we have all been inspired to believe that we can somehow inhabit or let alone find ourselves and each other within our proximity to these stars, in knowing and believing that we shall all become immortally christened and made whole and complete, as even before I am born within the birthing of these heavens, there must be an answer that bares all from within, bringing a greater opportunity amongst the sanctified stars of this sanctuary for all that is to be found in I Angel Haven.

You see ever since the creation or the birth of the heavens, or whichever way you would choose to define, or to look at the beginning of time, or indeed presume to come face to face with eternity, which also in itself presents me with its' own seasonal paradox, full of time warps and contradictions, and unexplainable events of phenomenon, that could only give way and rise to other intelligent and random bouts of lifeforms somewhat inconsistent with my own, or indeed my own perfect knowledge of sound, albeit that I am surrounded with the ideas that would otherwise propel my life into the immediate foreground, or otherwise become something that suspends me in time whilst relegating my thoughts and my thirst for life and peace back to the books of history, to be seen and treated as only a mere relative or redundant pastime, to be wielded as a mechanism that yields only the perpetrations of negative actions and results.

As overtime itself it is now within this aeon, that life has always reawakened to a new idealism, ever since the first beings could and would naturally paint and create graven images upon the walls of a cave, and such is this inspiration that history however impossible to record or collate or to make an intelligent case for, has somehow out of its' own nonsensical unpredictable quality, would in its' entirety, be at the very core of every eventful and eventual reality pertaining, and so it is only natural that the heavens should now open and be deemed a place fit for mankind, as it has by now, somehow come to represent the eternal prevailing sanctuary, or at least it has become revered as the invisible dwelling place of all that we associate it with.

As I have said that since I am called into being, then already, I have become awakened by you who call out to me from the very core and depths of your innermost consciousness, to be filled once again with the awe and the wonder of all things as of yet promised and conceived but as of yet unseen and undreamt, and yet still unrealized by many dreamers except by the simplest of simple believers and deities alike, that we all so often call upon to light, and to shine, and to reveal to us the unimagined vision and pathways, that we are all too readily and sometimes accidently uncover through an enlightened experience.

Although inadvertently this discovery allows us to be guided by the way of life, back to life, as we step upon the roads that more often than not, lead us to any and every place, and if not to my awakening then at least to my gate and my open door for each and every inquiring heart, but if you are not looking for me amongst the many stars in this rich and vast and wealthy Kingdom, then I must return back to the Emerald dream, until even I have forgotten and forgiven the reasons why I was ever awakened.

As I have also began to realize that life's messenger also speaks of a death sentence filled with grave news from beyond the crypt, like a forbidding silence that everyone must adhere too, regardless of what we would otherwise choose to believe and pray for in our hour of need, and how can I speak out to be against or for it, if only to believe, or to follow the idea or the notion that in some other form or guise that I must somehow in part or in spirit, been here before, but how can that possibly be, if the first time is the last and only time that my consciousness would reveal it to me, in my very own real and certain and practical presence, or indeed within the awareness of my being and within the sense of this the present context of my life, and who would agree with me that what was laid out before me, was somehow born out of my own doing and my own will in becoming inasmuch that history would or could repeat itself several times over, if only to perfect and compound my present reality, and as I have said in my own spirit, that time is motionless, except that that the clock itself would reveal it to me and tell me where I have been, and what I should recall, and how long I might live and endure, and indeed when I might begin to proceed to expire and cease to be no more.

But surely, even before the clock had first struck its' Almighty resonating chord, that there was I Angel Haven in and amongst the chief musicians if by chance and perhaps with a Lute or a Harpsichord in hand, listening to a song, along with the words and the melody once sung so long ago, or was it just as I had wished it to be, if only for me to be lost, and then to be found, and then to be reminded in and amongst the dreamers of the Emerald dream, and to then question how was time ever dreamt of, or captured within and amongst the many realms of the Empyrean.

As I can only think to imagine that these things were moments of places that I thought I had once visited or at least been too, as now I remember only too well that there was in truth, only the very beginning and the very end, which were both just as transitory and in accordance with themselves, in that time did not stop, nor did it begin, and now that life has only a messenger to speak of these things that could have been but never were, but could have possibly been, and so until the setting of the Sun crashes into the harvest Moon or vice versa, and the Planets fall out of line in disarray and disassemble themselves one by one, there shall I Angel Haven be, to witness and to watch and to witness the clock of superficiality and dysfunctional timekeeping, dismantle itself, without reason or feeling, or regard for the dreamers of the Empyrean.

As only the bad things inside of me can and must surely die and subside away, while all the good things that abide in me, must surely remain and survive, and endure as a testament throughout the ages of time, but who am I to say that this may, or may not be true, when I must consider my position and my options with regard to this statement, as my trial must prove to be complete, as to whether the world needs saving or not, or in fact whether the people in the world need saving or not, or indeed why bother as to whether anything or anyone might be in need of saving at all, and what am I to save them from or even for, and such is my dilemma and the conundrum in this matter, that such is the error of these inventions, to occupy and to distract my mind, and to divide, and to subdue it, and to keep it at bay, and away from all totality of reasoning concerning reality, as to whether or not that all I really need or want to do, is to just nurture and to endure with the instruction and the guide of this the saving grace of my own spirit, and to accept that this is the way of all things.

And so now that I have learnt of my convictions, and my debts of expectations to the one and Almighty one who commands and demands it, is to awaken to the every act that is committed, and in by doing so it must be met by its' own judgment or reward as to whether we are to be proved or examined beyond the conviction of this penance, or this sacrament of the symbol, or indeed the craft of this Angelhood, albeit through the make believe or the enchantment, or the illusions of my own responsibility which are yet to be realized, or otherwise thought through the silences of my every awakening hour to be cast out and forgotten, lost in my dreaming like the aeons through these passages of time.

And should I seek to rush to the farthest corners of time, to find my own escapism waiting for me beyond the edge of time, if only and surely to lead me to its' territory and vain hiding place, none of which I have the choice to seek out or rely upon, then surely it is better for me to wearily and drearily enter into the union and partnership of this the redeeming light without thought or delay, for the dream begins tonight, as it has always begun upon every night before the dawn.

And so as I hear the silence beckoning to me through the voice of my mother Mercidiah, speaking clearly into my dreams, please be kind to me and soften the blow that steals the breath from my lungs, casting shadows upon my mind, and please bring comfort to me in my loneliness and restore peace to my heart, as I have put my faith in you as the light of my life and salvation, and so the breath must become still, and the shadows of my life must run away from the light, and the lonely must be comforted, and peace must enter by the doorway, and the delivery of salvation must enter within all the places that has yearned and learnt to call out for its' attention, as for now I have paid for the penance with the sacrament, and I have yielded the symbol with the craft of the Almighty one who commands and demands it.

And so mercy must befall the Earth Mother Mercidiah, as it befalls upon all the many Earth Mothers actively attuned to the spirit and the nature of An Angel or indeed the spirit and nature of I Angel Haven, but then look, look at me and then see me no more, for I have followed in the ways of my fellow servants, and so too must all of you who are seeking salvation away from the corruption within the light of this world, but where have my fellow compatriots and fellow servants flown too, and how can I navigate myself between one world and the next, and pray tell me once again of the soul cages that have kept me captive for so long and away from amongst the many, and away from those of my fellow kindred souls who are by now at bay and asleep within its' secret bosom and enclosurement.

And pray tell me of the undying love and the fire flight of desire, that would and could unite every beating and breathing heart within this place called providence and sanctuary, and pray tell me of an Angel laid so low upon the plains of the Earth as a servant so remotely alone, once made to walk within and amongst the company of men, until a redeeming love would offer hope to come and unclip his wings and return loves' undying faithful back to this union of faith amongst the Empyrean sanctuary, and pray tell me of the other place of that which is, and that which was, and that which is now, and that which is to become again and again.

And pray tell me of Pablo the Immortal and the souls destined for this place called paradise somewhere between here, and there, and the place where they may dwell between here and the Golden Dawn, and pray let I Angel Haven, create a Heaven above for them all, as such is the prayer of promises and convictions, and such are the words of promises in spite of lies, and such are the vestiges of justice and truth, that I shall hasten to add too, and make a Heaven for them all.

As very soon the dreamers shall awaken from their unconscious slumber, and one by one their Qonshushmign's shall reveal their dreams of a new philosophy and a new star with a new name, as I can only but wait to hear of the much waited anticipated news of my calling to observe and to serve with integral tenacity if need be, in its' bidding, much before the dusk of their dawning has become settled, and much before the past has finally expired if only momentarily sustaining this temporary existence before mysteriously dematerializing and subsiding away, if only to become fleeting moments within the time and energy field that first gave it life.

As I am told to seek out the one who shall guide and allude me to the answer and the many revelations concerning all the many branches and variety of fruit that have sprung out independently and become individually born free of the tree of life, confirming that this transcendent star high above in its' orbiting of this atmosphere, shall soon be in orbit above the sanctuary and the heavens that conceal the Empyreans.

As for now I do not know long or how high I have ascended, or how long this flight of timeless suspense has laden me with this tiresome pursuit of weight and gravity upon and beneath my wings, for the place that I had to come too, had held me, and suspended me in a place where neither stars were shining, and where there was no moon which was ready to cool my wings, and too soon to be seen there was no light which was lit to guide my way through the unchartered ever more higher and higher atmospheric orbit that now presided over me.

But that was only until my sight grew dim and my way seem to falter, and my weakness became feeble and I felt faint with exhaustion, for this atmosphere was much too much to sustain me and my body to the fullness of my failing vitality, and such was this moment of a slow and dying but painless death which would not pass, except that I did see the light of the one that had called out to me inasmuch that I too had expected to meet with this news carrier bringing with him the message that I had endeavored to seek out and hear.

But within my expectations it was not how I had anticipated it to be of a warm and pleasant welcoming nature, but instead he did all but ferociously and with aggression and with much intent snatch and grab away at the very core of my spirit and being until I was at the mercy and the surrender of his attacking assault, and now being in fear of my own life being consumed by such a strong and mighty opponent, whose presence and appearance I might hasten to add, which all but hid his face beneath a veil while glowing and illuminating the atmosphere round and about, with his fully charged spirit of life almost drawing upon and weakening my own spirit, like the dying and fading embers of the fires within my own life force, which were by now being pulled out from within me internally, but before I lost all consciousness, I was freed and loosened from his fury and fiery grip and allowed to gain some form and composure of awareness and control and stability over my very own fearfully threatened disposition.

As now in facing my opponent and adversary I noticed that his appearance was of the same if not similar form and fashion of mine, except that despite the fact that I could not see his face beneath the veil, he seemingly felt and sounded and appeared to be the same as me, as I also gazed upon his form, I soon realized that he almost encompassed a glowing aura which shone the color of a yellowish brightly burning bronze resembling something like that of the sun, while I myself upon reflection seemingly only appeared to reflect only the whitish grey illuminations of that which may have resembled the moon.

And so now without knowing the full implications of this eventful meeting, I simply began by asking one simple question, which was to begin with, who are you, and why have you attacked me mercilessly I somewhat fearfully uttered, I am you he replied, but how can it be if I am me, yes you are you he replied, but I am also you but you are not yet me, then how is this possible I asked of myself, because I am the future and you are the temporary present, but I came here to receive word of a new star in orbit about the Empyreans I replied, and so you have he replied, you are the new star, but if I am the new star then who are you, I am you he replied, but what has brought us here I asked of myself, the tree of life has brought us here he replied, but how and why is it I asked, because where I have come from the tree of life bears no significance. But how can that be and where have you come from I asked of myself, I have come from you and from your future, but if you have come from me then what is my name, your name is Haven he replied, and what is your name I asked of myself, my name is Zyxven he replied, well then you do not come from me nor can you be me I replied, as I have said I have come from your future which you do not yet know, then tell me why the tree of life has brought me here to you, the tree of life has brought you here because it is now desolate as you have already said and because the branches do not correspond or know their roots and because you have spoken it in your trial and observations that one star makes a world and that several stars would create a universe and that several billion stars would create a galaxy but only if the tree of life were to sustain it.

And did it I asked, no it did not he replied, but how can this be, the tree of life is the product of the Empyreans who guard and protect over it, yes but as you said in your naivety if the sun fell from its' position and crashed into the moon, or if the planets were too somehow become unaligned in disarray then ultimately the tree of life could not abide nor could it stand, so what you are saying that within my deeds and actions that I have caused this to happen, well yes and no said Zyxven, then what is it I asked, it is because you are Haven, but what does that mean that because I am Haven that I have caused the tree of life to die that's a lie, but you yourself have said that you want to make a new heaven for every and anything that lives and breathes beneath it and for every verse of truth in spite of the lies, but that's absurd, is it, yes it is, well what I meant was love and happiness I simply wanted to make a heaven of love and happiness, then why did you not express it and then fail to present this wish and desire to the Empyreans.

Because naturally I thought that everything would be reflected and understood within my nature and how I had imagined it to be, but I see now that this is not true, of course not Haven because you are young and full of innocence and awesome wonder in so much so that the stories that you were once told in the cradle of life have allowed your imagination to run wild within the heavens along with this idea of hope and perfection and salvation, but what are wrong with these ideas I asked, are they not true and perfect values to aspire and to desire too, and to want and to need, I did not say that Haven, I simply believe that you were being naïve and unrealistic.

But why tell me why what is wrong with innocence and virtue, there is nothing wrong with innocence or virtue Haven but even you must know that a lie cannot empower the truth and yet the truth remains hidden beneath a lie because even the inhabitants of Earth could not overcome or surrender to the harsh and unbearable truth and yet even more so and unto the end, albeit that in the end the lies may also become the truth, so what do you mean Zyxven, I mean are we at such an end that nothing can be sustained beneath this reality except that which we have already dreamt into being, but I am Haven, yes you are and you were, but I am Zyxven, but what is this demonology concept that we should be pulled in together and enter into this existential paradox if you are me then prove it to me, there is nothing to prove Haven did you not feel that I had disempowered you and placed my hands upon your spirit, yes I did but that proves nothing, then tell me when was the last time that you had seen your mother.

The last time I saw my mother, I cannot recall but it was not such a long time ago I think, or rather I recall that she had been visited by the Earth Mother I've come to know as Kali Ma and they appeared to be very reminiscent and happy, and she was in the prime of her life but why did you ask me that, I asked you that simply because where I come from your mother or rather our mother is dead and she has been dead for some time, and by now her body has been laid next to the tomb of the Earth Mother Selah within the Godstone burial ground, although by now I think at this stage that you may barely find remnants or traces of her transcendence which have taken place somewhere in the soul cages.

Our mother hallowed be thy name, our mother is dead but how and why, and why don't I remember this, you don't remember this simply because most of your thoughts are mine now, as are your memories, which have also entered into me and are also mine, but why Zyxven, why is this happening now to me, to us, to you now, why simply because a new star is being born that is why Haven.

But tell me it's not true how can this be, how do you come to know all of this when I tell you that I have seen and even felt the presence of our mother Mercidiah alive, as I have said Haven part of Mercidiah will always be with you in spirit forever but I can assure you that she is no longer the living embodiment that you once knew as our mother, you lie, how can I lie when the truth cannot conceal it, but it cannot be true, yes Haven it can be true for a lie could not conceal it upon revealing it to you, but how Zyxven, why, where, when, how do you know all of this where do you come from, well whether you choose to believe it or not Haven I have come from you.

But this is madness, insane, folly, yes indeed it is very hard and difficult to acknowledge and to accept it but it is true, then if it is true then I too must have died, no it is not so Haven, well then you have to come to kill me or to finish me off, no Haven I have not, I have come to fulfill my obligation to you, obligation what obligation how can it be that you would bring me this sorrowful news of my mother passing after seeking to state that you have come from my future eternal and to then attack me and to then seek to inform me that you have come to serve me, I know of no obligation or request or bargaining that upon my head which would be in need of service to be performed for my undertaking or for any other reason of fulfillment, but there is Haven, then what might that be.

It would be the one to fulfill the Emerald dream, but what is my part and position in this forthcoming event surely the Emerald dream is that of a nature to be proclaimed by the Qonshushmign's and by them alone, in order to yet awaken from their slumber to bring clarity and meaning to this reality prevailing where there was once none, well yes and no Haven, as their dreaming of reality must be fulfilled and yes it will be, but not before I am gone, gone where, well that is up to you and I to decide together before this reality ceases to exist and for theirs to take precedence over everything else in the here and now.

I do not understand Zyxven if I am readily in acceptance to make an agreement with myself, and if you already by having the upper hand in knowing my future, I did not say that I knew your future, I said have come from your future, but what is the difference Zyxven, the difference is that in my being here the future has already been changed and altered and so we must take new steps in order to fulfill the present and current future, but if that was your intention all along then what if I am to fail in this agreement or this so called obligation as you so put it, because you have not yet already done so.

As I am aware that once upon an aeon ago in your existence amongst the Angelhood of the Empyreans you were ordered to write a book which was then later forgotten and discarded as a mere theoretical piece of literature that could not be used or assigned as an influential piece of material for its intended purpose or interpretations and meaning, and that it was this book along with several other less important remnants and artifacts, which were put beyond our present reach and understanding, yes I remember being in a certain place and under the sphere of an influence, as it was around that time when my father Angel Simeon had relayed to me that his time spell was coming to an end and was about to expire.

Yes that much is true as he transcended into the several worlds but I cannot clearly remember the book of which you speak or what it consisted of, that is not important right now Haven as we too must enter the realms of the several worlds, but before we do so, we must sip, and drink, and taste the dew of the sea of glass, and so now I must bid that you come with me, as I can feel the energy of the Qonshushsmign's pulsating beneath my wings.

Eventually as we reached the sea of glass, there in the not too distant horizon was an Eagle having multiple wings, which did also descend from the skies above and drew near to me whilst taking refuge by my feet, as it too was also closely followed by a winged Lion which also drew near to me whilst taking refuge roundabout where we stood, and this too was also followed by a winged Calf who did also gather near to me there where we stood upon descent, and then soon afterwards a Man having multiple wings did also appear to me also gathering near to where we stood, and upon their arrival, they did not speak to us or make a sound, as if to only be in observation of our presence amongst them, and so I thought to myself that perhaps it could be that their presence here amongst us was also an indication of something that Zyxven had said to me concerning the tree of life, or was it simply that they were indeed only here as merely to stand as symbolic representations or incarnations of their former lives that had once dwelt upon the earth.

As much to my surprise and upon their bidding, they did indeed indicate and gesture to us, as if at their behest and supplication, that we should indeed drink the dew from the sea of glass to replenish ourselves, and just as we had finished drinking, I began to feel a surge of energy and renewed vigor of life enter into me, as I somewhat felt my spirit had become much more alert, and much more attuned, and uplifted up by this experience, as if I were becoming much more empowered from drinking and sipping the dew of the waters, and it was upon this renewed feeling in my spirit and upon reflection, that I also began to realize and notice that somehow my friend and companion had experienced the opposite effect of that which I found to be profoundly striking to my nature.

And the feeling was that Zyxven had somehow become much more weakened by this event, or that his life force had somehow transferred itself into mine through the properties of the water, as I now began to realize that it must be true, for at this moment before Zyxven was to rise to his feet, he all but uttered a few simple words, as if in the act of performing a prayer through some form of meditation or transcendental grace by simply uttering the words, and should its' branches splinter and break off, so too shall they be gathered up and prepared for the new harvest, and should its' leaves become scattered by the wayside, then so too shall they be gathered up and made ready for the new harvest, and should the fruit become overly swollen and heavily laden and fallen from the tree, then so too shall they be made useful and gathered up together for the new harvest, until such a time that all things have become gathered up and taken into stock and made perfect and wholesome, and so too shall they be prepared and made worthy for the new heavens.

And as my confidence grew and my strength and my spirit was renewed by the dew from the sea of glass, in just one simple but sincere and overcoming realization, I became much more aware, and much more sensitive, and conscientious to the relativity of the greater good of my friend and companion, but now somehow my doubts and insecurities had also doubled and increased in capacity, as I also felt my connection to him, had intrinsically become much more increased and amplified, that not all that Zyxven had said, had become completely fulfilled or nourished within him but remained inquisitive and unanswered inside of me.

Or could it be that upon Zyxven's silence and departure from the sea of glass, that he had somehow caused my conscious thoughts to flow freely from my mind without walls or boundary's with which to contain them into his, or that somehow my knowledge was truly fulfilled and now finally complete and overflowing without any concepts of time or limit, or was my friend and companion about to return to from whence he had come, for if it were not for the presence of the future of which he spoke to help me from my past even though I knew or felt that somewhere in and amongst the several worlds that my father was now dreaming but of what I did not nor could not know, but as Zyxven had directed us to go there first, then perhaps the remaining Angels of the Empyrean will come to know of the why or the wherefore that somewhere between the here and now and the time of which he spoke, between my becoming from being Haven to being Zyven, or indeed why it was that the tree of life has become so desolate and sufferable in such a way as my friend has described and spoken of it, that he himself had come to fulfill or at least write a new chapter within this event.

But just as the thought has entered into my mind before randomly leaving once again, Zyxven began by saying to me, my friend it is true to say that some of us have a deep and dreaded fear and are afraid to live and to go on any further or another step in this life, as we have grown cold with fear and we are without the will of fight or flight to strengthen our souls even against our own conscious reasoning, as even the most mortal of souls seeking direct communication and union with the host of Angels would indeed pull us down from the heavens and trample us beneath their feet and into the ground if they could.

As even in this reality and future prevailing I do not know what the Qonshushmign's would dread to fear the most, or better yet to reveal to us in this their reality of believing or thinking or even dreaming that either the consequence or the consciousness of either eternal life or eternal death should be sustained, or even how long the elders could be beheld upon this account of such a divine principle to give themselves the deciding mantle to deliver up generation after generation, I mean after all is it not useless to deliberate upon such irrational and dreaded despair that is not of our own making and choosing, for what is life when the host and the ghost are one in the same, and is it not you and I that have both become set apart and upon this path with destiny itself.

As I do not know when or whether the tree of life shall become fruitful again to be found bursting back to life with renewed strength and vigor and vitality, insomuch so that even those the men of earth who have fought so tirelessly and relentlessly in only seeking naught else but to uproot it and to examine it by proclaiming themselves as lord and master of its' domain, and yes although we are their servants, inasmuch that we are all each one of us held together by this one singular strand of truth, but also in knowing that the Emerald dream is all but for now, only one dream amongst many, and so it is only natural that this and their decree and proclamation shall issue forth and bring together another harvest with the likes of which none has ever been witnessed or seen before, and whomsoever and whatsoever mighteth remain shall not be cast away from our sights, but whatsoever shall perish and is also to be put away and seen no more, then let us at least believe that this shall only be that which seeks or has no part or place or desire to be amongst us in this the sanctuary of our garden amongst these stars that we too shall also gravitate towards.

As we too are also to be examined in this the judgment over the rights of life and death, and so soon shall it begin that when we arrive upon this dawn and within this the heavenly conception of the first becoming of the several worlds, that this universe shall begin to move and to reconfigure and to realign itself, if only then to usher in a new star much beyond that of our reach and comprehension, that none could yet behold, as of yet I am sure that you my friend have renewed my spirit and given me much courage, and so do not let me cause your worries or despair to linger for a moment longer for our father thou art in heaven, and so we to must take refuge and comfort from this fact and also from each other, that when we enter the first becoming of the several worlds, that our eyes shall become open to the eventualities and possibilities that these as of yet unanswered questions and knowledge's that have been brought to bear upon us both shall be answered and fulfilled, and in being there that we shall also learn of our fate and desire and if indeed Haven is to be given over to any authority or power deemed worthy to be done according to his will and upon the earth as it is also done in heaven.

And so it was that upon the first steps of my anticipated and surprising arrival at the beginning of the entrance into the first becoming of the several worlds, which was one that I had met with indescribable if not spellbinding magnitude, and one of striking bewilderment that was nothing like the way I had imagined it would be, or indeed in recognizing that it did not bear any resemblance to the world which I had left behind in my place and position amongst the remaining Angels and hierarchy of the Empyreans.

As this was but another world of both beauty and wonder found and to be realized and as entertaining as a world within a world of infinitely abundant, and sophisticated, and endlessly highly evolved and somewhat naturalistic and intelligent unimaginable constructs and forms of life, that gave way to an outer limitless living structure, where I could only begin to wonder and realize the multiplicity of this multi universal structure, in a place without boundary now somewhat teeming with ethereal and organic free flowing substances of life forces from one realm into the next.

A world embedded or at least encrusted within an infinite number of stars and Angelic like creatures, seemingly to be any and everywhere, whilst encapsulating the light all around and about me, as if by some force of reanimation or recreation, every life form that had once been or at least had become, was now somehow embedded in this living and life sustaining solar system.

Or could it simply be that this was called the first becoming of the several worlds for some other reason other than what I could identify with, or quantify, or even let alone imagine beyond this initial point of impact and amazement, for as of yet it was even harder for me to engage or to realize upon my initial reception, how vast and wide and open this world within this awesome place of wonder could truly be, but as much as my mission was only to find my father amongst these many living creations and manifestations of new and rejuvenated beings, that in truth I did not know where to begin, inasmuch that it could be that there are or at least there were many more transient worlds even beyond this one, as I did not know where it could end.

And so now I had to focus my efforts and energy upon a flight of discovery to take and guide me even deeper and further into this myriad of complex infinity, so as to interact but not too distract myself away from my desire of reaching and finding him, but even as we had entered into the first becoming of the several worlds together, it was just as I took my first steps to ascend and to gather my thoughts and my wits about me, that I soon realized that Zyxven had become somewhat hesitant and reluctant, and did not wish to pursue, or to follow me through towards this new and eventful horizon, as if he knew too that I had to face this part of my journeying alone, or could it be that he knew something more about this part of my trial and future than even I had yet to encounter and as of yet did not fully realize or comprehend concerning its' probability and outcome.

And yet in hindsight it was true, for unbeknown to me in the present context of my conscious mind, my father Angel Simeon did indeed appear but not to me as I would have wished and wanted for, but as I did not know it, he appeared to Zyxven as he stood there at the entrance awaiting for my return from the first becoming of the several worlds, and so as I searched frantically and desperately to find and seek him out, hunting both high and low to learn and inquire after him, if only to find the truth and the understanding within the many things that Zyxven had relayed and conveyed to me concerning the tree of life and the Qonshushmign's, but little did I know that they were already engaging in a conversation of exchangement upon my departure, as by now I was already beyond the point and the powers of my perception that my father and my future self embodiment were already as allies aligned together within some form of communion.

My son you have already transcended the natural heavens to seek out governance as to what you must next now do and what must become of the many things that you have been witness too, and so is this reasoning not enough for you to take stock and initiative as to what decisions and actions that you must now consider and take responsibility for, as each one us holds a position of power to exercise good judgment and positive restraint and composure over our independent will, inasmuch that we are all bound together within a duty to fulfill its' ambitions at this present time within the sanctions of this aeon.

As for me now, you must also be aware that my position here is only to serve and to take up my place beside Hark the Herald Angel and the Elders of this the becoming of the several worlds, as your arrival here is almost certainly one of an unfulfillment born out of fear or destitution that all is not as it should or could be, but we must be patient and obedient in our observations to the will that has presented itself to us, as our meeting like this is somewhat premature, as you have always known that the father and the son can only but dwell in the same house of existence if only but for a little and short while.

For as a mere child I brought you here with me into the house and the dwelling place of the Empyreans for the sake of your mother Mercidiah who did not wish for you to become an earth Angel like the celestial kindred spirit that you have come to understand and know as Stefan or Angelo, but as a celestial being somewhat conceived of heaven and earth, it is only natural that you should go on to uphold the firmament of all living sentinels that gather themselves together and congregate high above and below the skies of Nejeru where we are likely to transcend, ascend, and descend, inasmuch that your place is rightfully beside that which is in the sights of your domain.

And in by doing so the firmament of heaven will be cast once again upon a new star that has come forth to spread its' wings, but as for now you must return to the Empyrean and watch over the earth from afar, up until when it has proven to be renewed and redeemed by the Qonshushmign's, and then you shall find your inquiring answer there concerning the tree of life, as for now I must return to my place amongst the Elders and Angel Hark, and remember my son, that what I have told you, that you must also remember to tell yourself of these things that are to come, for whatever happens on earth, must also have happened somewhere within the heavens, and with that my father Angel Simeon was gone and nowhere to be found or seen within the first becoming of the several worlds, and yet soon after I would find myself returning to find Zyxven waiting for me, and to receive me in my disheartened state of not finding my father within this the first becoming of the several worlds.

As time itself was indeed by now instrumental, as well as being vast and wide, and much without the thought of regret and comprehension or doubt, as I had even begun to consider that I would not now find my father here amongst the celestial beings of the first becoming of the several worlds, but just as I had decided to give up my search and to seek out Zyxven once again now awaiting for me upon my return, and then without a warning or reason, the atmosphere begun to rapidly change round and about me, as did the winds within a season begin to quicken and to hasten, as did the clouds begin to violently roll high above me, as did the skies begin to darken, as did flashes of lightning spear across the sphere of its arc, as so did the thunder echo and roar bringing with it delicate droplets of clear and crystallized water, as did the air become filled with an element of intensity, whilst creating a deluge of waterfalls from the higher places above now found to be raining down upon the valleys below.

And so I began to feel tense and fearfully panicked, as if my being here had caused a swift and chain reaction within the elements of this new development, and so swift was my reaction to depart from this place that as I turned to leave I was mysteriously approached by a member of this transient and celestial world, who had taken it upon himself to inquire as to the nature of my presence here amongst them, and then soon after my revealing that I was indeed in search of my father Angel Simeon, he acknowledge me by pointing me in the direction of which I was about to take.

But not before revealing to me upon my departure, a book of somewhat obscure familiarity, with which he handed to me, upon which I did not initially notice had no reference or distinguishable markings upon it, and with just one remark he simply said put the book back and return it from whence it came, and with that remark he disembarked and I was free to go, but still the thought remained imprinted within my mind, as I did not know what he had meant by simply saying put the book back, a book with which he himself had readily produced to me, as if he were somehow in anticipation or ready and waiting at hand to engage with me in this poignant act, or was this simply something that my father had instructed him to do, or indeed that Zyxven had organized him to do, or was it simply something that this being had taken it upon himself to do, as I truly did not know of its' meaning or implications, or was it something of which I was yet to learn or become aware of, for as I received it I was now completely compounded by an element of deep confusion.

And so upon my ascent I eventually found my friend, and somewhat profoundly inspiring spiritual soul mate, but he appeared to be somewhat anxious and nervous to greet and receive me upon our meeting and reunion, as I was also somewhat anxious and in a state of renewed interest and vigor that I could now announce to him the gift of the book, which I believed I was to return back to the realm of the Empyreans, although I was not quite sure or even certain that this is or was exactly what the celestial stranger had indeed intended or otherwise instructed me to do, and so I was in anticipation as to what Zyxven would indeed say or at least do at this point in time concerning this revelation or reckoning, as something also appeared to be troubling him at this point in time.

Did you find our father upon journeying into the first becoming of the several worlds he asked me, no I did not I replied, then how is it that you possess this book he inquired, it was a gift I replied, given to me upon the merit and understanding that I return it from whence it came, return it to where Zyxven asked me, to the Empyrean I said suddenly, then Zyxven began to laugh out loud, don't you recall anything he said, nay why I do not, but why, and what should I recall with such humor, the book he said, this book in your hand that you are now holding, have you completely taken leave of your senses upon your return from entering the first becoming of the several worlds.

Well maybe my senses do not serve me as well as they seem to serve you I replied, yes it is true we are one Haven, but I know this book in your hand, in fact I know this book very well, you see this book is the one I mentioned that you once wrote and was discarded long ago, then how be it that it is handed to me here from a celestial being within the first becoming of the several worlds I asked him, this much is confusing I know, but I do not know how it came to be located here in the first becoming of the several worlds, but I do recall it to be the book that you had once written, then why does it not carry or bear any seal or markings or detail, well I believe that is because somehow it has become unwritten.

But how is this even possible if you seem to remember it and I do not I asked him, I recall it because I am Zyxven the sanctuary of Haven and you will do well to remember that, but perhaps somehow my being here has caused it to become unwritten, and then again perhaps it has to be rewritten or written again, or maybe perhaps by design you are to return it to me, as my future is yet to be written, but come now Haven for we must once again take leave and return to the Empyrean if we are to find the answer to this conundrum, as I believe that we shall find more of the news concerning the Qonshushmign's and the tree of life waiting there.

And so upon our return to the skies above and the realm of my spiritual home and birthright, I did indeed gaze down from afar upon this somewhat celestial palace and constructed maze, standing like an ethereal colossal and infinite coliseum of fortified precious gem stones, reflective of a shimmering citadel that circled in and upon itself, between two towering axis points, within a sphere that was indeed placed and embedded inbetween the expansive heart of this the higher and that the lower part of the mid heavens, standing like a towering forum giving height and depth to the sanctum and the dwelling place of the Empyreans, where I could make no true breathtaking distinction, or clarity of remark, or comparison upon its' superior and majestic splendor and beauty, now to be compared with that of the newly disclosure of the first becoming of the several worlds with which I had become witness and subject too.

But such was this variable of vast distinctions and yet the difference between these two interactive connections, and the difference between these two celestial dwelling points that I had come to know, had almost led me to forget why I had indeed returned to this place that I call my home and sanctuary, but yes now I recall why in my infancy along with the expected thought of the future prevailing with such an instant and perpetual motion, now found to be transcending my thoughts internally, whilst giving birth to me and rendering fear into my heart, along with the emotion of such a reluctant thought that would enter and engage with my spirit, for this fear had now taught me that a world without form or structure can so easily, and so quickly descend into confusion and soon become a world corrupted by chaos and pandemonium and full of hysteria.

As I too was also impassioned to give an account of my own dreams, that would and could contribute to the great will and unimaginable concept of the Qonshushmign's, who might once again upon a desire learn to aspire and to adapt themselves to the greater expectations of creation with such an almighty equation and unifying aspect, that would naturally stem from the sub conscious hearts and minds, of each and every one of us found to be dreaming and sharing in this singularity.

And so as well as making preparations for the birth of a new star, even before the one I may be called to eventually serve as a deserved reserve, or to one day eventually take my place before the judgment of the Elders in the first becoming of the several worlds, but if only I could recall and remember this book that I had once written, that had now somehow been returned to me once again, and is now back in my hands, but what am I to do with it, and how am I to attempt to write it once again, and what if I have forgotten and failed to remember what I had set down before me, or indeed what I should write again to begin a new chapter through these recent revelations of my enduring testament and translation of what I have now recently seen or become subject too.

And what of it, and what if Zyxven does indeed possess the future knowledge of that which has beckoned out to him and brought him here now to me concerning a future that may or may not now be written off, born out of something that still remains unfulfilled, a secret perhaps somehow withheld by the sacred Elders of the first becoming of the several worlds, or perhaps now or never to be revealed, or kept, or to be sealed by my lips, or even to be held and dictated by my fingertips, and now once again somehow tragically it has been handed and given over to me, as even now in this my trial I must try to recall my own statement and content of philosophy, to give an account of such tasks and trials that even I Haven must have known that it began with me and the tree of life, as well as becoming born of this, the engaging reality of my own embedded fear, that mankind and humanity might one day fail in their pursuits and endeavors by causing, or at least bringing planet earth and the heavens of the Empyreans into disrepute with one another.

Or indeed that the heavens might one day cease to move, or shake and rumble with the idea that in this moment, the Emerald dream may not prove to be influential enough, or may not even last much longer than this the next aeon, but if a book were to be written underpinning all these threads that tie the heavens and the earth, then who would or could write such a book if not I, and why should I write it if it has already become unwritten, or am I to be found without reason or counsel, or strategy and defense, or obligation and duty, and who would look upon it as being worthy or full of worthlessness, and who could it serve unless to save the Angelhood or the celestial beings of the Empyreans and to those who occupy the several worlds.

And who within these heavens above or indeed this earth below be able to find mankind unfavorable in the midst's of their sights if not I, and so I must therefore remember all that I can before my spiritual companion is gone and no longer to be found by my side without thought or reason, that I Angel Haven am already somewhat at a loss without him as a guide to lead me through to my destiny and the passages of my own life.

My friend inasmuch that you are somewhat in doubt and confusion as to what is now required of you to do, in order for the name of Haven to become one lasting symbol, now to be seen as a synonymous union over the skies of Nejeru and the heavens of planet earth, or indeed to encompass the regions of the first becoming of several worlds, then let it be known that the name Haven shall become to be proclaimed as the new heavens over the earth, as all these former things must now also be shed and pass away for us to also be remembered and forgotten in time if need be as a lasting promise and fulfillment across the passages and the aeons of time, until such time as they may cease in their hunger and their journeying, or even until such a time that the aeons shall and will eventually prevail upon us all, within its' eventful succession, to repeat at will, and to strike at us once again with its' harmonious and melodic chord.

But as for this book that we now speak of, shall not be written by a hand that yields a pen, nay surely not, as this method of action can surely not contain all the truthful and worthy merits and elements that are needed, or even required to speak out and to translate to the heavens what is needed to be done and said, and as to what is already written and contained within the heart of such a young and youthful innocent Angel such as the one that you now seem to possess Haven, and yes indeed our father has spoken it and revealed to me, that it is you and not I that must return the book from whence it came, and it is also true to say that we two must also return too from whence we came if we are too carry out its' every instruction, but the book of which he spoke was not the one that you now hold and possess in your right hand, but that of which you are, as you are the book of which he and the Elders are aware off and spoke of, inasmuch as to what is written inside of you Angel Haven.

As nothing can be set as to what is yet unwritten, but how can I be the key to this book that embodies such a redeeming and unwritten law, nay surely that would somehow give way to the interpretations of a miracle, as I have said Haven, the future cannot be told if there is no one here to tell it, as even now you hold the secret and the key to this future, and so now only you can reveal it, but how can I reveal it, what am I to do, and what measure of sacrifice is expected of me to deliver and return this symbolic book back to its' rightful place within the Empyreans, if I am only permitted to do it through the representations of myself.

Everything is connected Haven, as is your mind to your thoughts, and your spirit to your body, as also are the skies to the earth, and as are the seas to their shores, and they are all only inseparable except that they all possess their own inhabitable space and unique elements and quality, as all are defined by their own special pulse and energy sphere within their own composition and original properties, and so you must also imagine and trust in your judgments and findings, that the tree of life is also of an embodiment that also has its' roots deep in the heart of the soul of the earth and rises up, so much more higher and further through the channels of life, expanding and extending its' branches far beyond the reaches of this universe, and above and even

higher still into the infinite realms of the first becoming of the several worlds, and even higher still striving beyond the galaxies, as it is this tree that shall account for the multitude of souls that are to feed and to yearn and to flourish upon the soil of this universe, that also equally gives nourishment to the stars above, and that are also conceived of their own important unique properties and composition, whilst occupying their inner space that they too must also gravitate towards.

And it is this tree of life that is also laden with the many fruit that have once been brought to bear upon its' branches, along with its' many burdens of which to maintain and sustain itself as a life support system that many would indeed take for granted as far afield as possible, as many indeed would also come to seek reassurance and guidance from its powerful properties of a somewhat unconditional and life sustaining and delivering entity within its many arrays' and forms.

As it is this tree that shall become desolate if we do not act to support and to influence its' nurturing and growth, by using our will and all the forms of our knowledge and understanding of it, in order to preserve and to restore it and us, back to our once and never ending glory, so come with me now back to the sea of glass, and I will try to example and show to you what is to become of me after these former things have passed away, so that you can choose and decide what manner of things you must do in order to fulfill and follow in this reasoning.

And so as we extended our wings and became airborne once again destined for the sea of glass, I could not help but recall that once upon a time within a remote place beneath the tree of life within my sanctum of the Empyreans, that there within my mind's eye, an image of a young aspiring Angel sat with a book in hand, quietly writing something that only the inspirations of those who could be born from these heavens could and would undertake to write to these dictates, and yet why was I even inspired or even allowed to interpret these primal ideas of inception that would cause me to think, and to move with my every thought and reaction to manifest itself as if indeed I too who were only born and formed from an earthly woman fertilized

by the celestial seed of an Angelic like substance, would be obedient to its every will in my awakening, and yet even now in my reality prevailing, everything seems to gather ground in the here and now to present me here with this the choice of my own idea, that it is only now that I have begun to realize that my part however insignificantly conceived in this mystery, was now one of little consequence as to what might or might not happen, or could indeed already have happened and been declared and presented to me by my higher self.

And so now it has become even more so difficult for me to remember, what I could and should do to recall, or even hardly forget that what I had once written in this book was now somehow coincidently connected or coming to present itself to me as a self fulfilling prophecy, and so I would have to be sure of the way, that even my trusted friend and futuristic companion Zyxven also could not account for this chain reaction of events upon this anticipated flight of self discovery, and so once we descended by the water's edge of the sea of glass, without hesitation Zyxven stretched out his hand and set forth upon rippling the waters beyond, creating small waves, whilst softly speaking the prophetic words.

Inasmuch that I know, that even beneath this the deep seas of their imprisonment within the belly of a fish, shall the souls in their soul cages. not be lost or forgotten, in my declaring that this is the harmonious chord of the silent and the naked, and this is the invisible unheard melodic chord of the life force as it transcends and travels through the echoes of an inner voice, a voice that reverberates and resonates as its' own pace even unto the roots of the tree of life, and this is the voice of a language that none can hear except those that shall know of its whisper and inquiring, if only to become awakened by the vision it chooses to bestow and invite upon them to interact and become inspired with at its beckoning and in its' summoning, as this is the voice that shall come to fall and touch upon those the dreamers who shall duly see that it is they who do indeed possess the Qonshushmign that has now become fulfilled and lifted up and gathered together beneath the glory of its' living wisdom, in the event that we shall soon see the new star revealed to us, through the spreading of its' truth and the opening expansion of its' wings, upon and over the heavens below.

And with that message the water's began to stir and swell evermore rapidly, intensely swirling round and around until they had erupted into a violent whirlpool, and as they did so too did Zyxven begin by wading into the water's until he was completely covered and submerged by the deep and consuming water's, disappearing beneath its' surface, and could be seen no more, and as the rapid waves encircled vigorously about him, becoming like a vortex swirling round and round like a pool of immense intensity, I too waited and waited and watched as to what this event might lead too and give way to next, or indeed what might happen or transpire next from what he had said to me concerning its' silent message of intent and language and purpose of vision, and as I waited and waited with anticipation, nothing did transpire nor transact from this action, except that the water's did just seem to intensely encircle in and upon itself whilst stirring evermore violently until the core of this vortex had become bottomless and was by now without partition or limit that insomuch it began to lash at my feet.

And as the wave's washed at my feet, I began to feel it's energy and force empower and enter inside of me, as I began to ponder this feeling of release whilst I began looking around my whereabouts, where I noticed that not too far in the distant horizon, the winged Eagle, and the Lion, and the Calf, and also the winged Man were by now watching me as these events were unfolding, as they also softly whispered and began by singing and giving praise saying Holy, Holy, Holy Lord God Almighty who was, and is, and is to come, and it was only by then that I knew and began to realize that my trial was at an end by the water's edge of the sea of glass, and so I took it upon myself to cast the unwritten book into the raging waters in knowing that my journeying was complete.

But then for a moment I remembered one last thing that Zyxven had spoken to me when we had first departed from the first becoming of the several worlds, inasmuch that I did not quite know what he had meant when he said I am Zyxven the sanctuary of Haven, but in that moment I felt a sigh of relief come over me, as I was somewhat comforted by this realization, and so I had decided that now was the time to follow after him by entering into the sea of glass, until it too could and would swallow me whole.

And whilst I was twisting and turning into its' rapid descent, spiraling through its' vortex, it began by pulling me further and deeper down into its' core, until all I could feel was the life force and the gravity of the water all about me, and much more than that, I could feel the energy of the water flowing through me at will and entering into my veins, and that somehow Zyxven was by now united with me together in the waters as one Angelic force, forged and transformed by the water's within the sea of glass, and as the vortex was by now pushing and pulling me down toward its' belly and propelling me through its' core, until everything suddenly stopped and became motionless, and quiet and peaceful, and the surface of the waters had once again resumed their calm and stillness.

As I soon finally found myself within the core of its' belly, with which I soon then began to gather the feeling and the momentum to once again fly upward and through the center of its' core, where upon my struggle to break free from the imprisonment of this abyss, I stretched forth my wings sending out and issuing forth beams of light before me, like the birth of a new star shooting through and out of my spirit like the rays of sunlight all over the sea of glass, until I was ejected and propelled through to the surface, knowing that I had somehow brought forth the new heavens and also by knowing that my spiritual companion and friend had also become my sanctuary.

As I soon came to realize and understand that this was the birth of a new star of which he had spoke, and this was also the awakening that my soul had resounded throughout the Empyreans and the first becoming of the several worlds, and of course would send out a message that would in all eventuality strike a harmonious and melodic chord with the Qonshushmign's, as this was for me a new beginning, and so upon my resurrection and rebirth I did not know whether the Qonshushmign's had awoken from their unconscious slumber and sleeping or not, but in order for them to issue forth a summons of me in their influential and unimaginable dreams, was soon yet for me to be realized as a potential and prevailing force upon the order and the hierarchy of the Angelhood, with which I knew would instantly have a deep and lasting impact upon the face of the earth and mankind, or indeed whether the Emerald dream had already started to take root or effect or not, but at least as for now I was conscious and aware of this event, and in knowing so, that I might somehow through the will of my actions indeed help to balance the heavens and bring into accordance the birth of my place within the Empyreans, betwixt the mid heavens and the earth.

But for a moment I was immediately drawn to the thoughts of my mother Mercidiah, and whether she were still alive through the narrative and the chapters of my tumultuous journey that I had taken into the vortex which was now for me, far beyond any doubt or revelation which had indeed changed the elemental fate of my destiny, and so it was only natural that my earthly and Angelic heart should seek her out to find assurances and peace of mind concerning her safety and welfare, and so now it was time for me to take to flight and to descend homeward toward the earth and her domain.

And it was upon this flight that I could not help but think of death and disaster now somehow persecuting and pursuing me in my tracks, whilst I was coming to terms with the fact that my former existence was now one to be born out of fear and desolation, and in my initial abandonment of hope and optimism, I did not stop to even think or consider, or even truly know if my trial had ended or resulted in bringing about the same consequence of my fate upon the earth, or indeed whether my actions could result in any other consequence of change brought about by my trial and being, as by now I was steadily and rapidly approaching earth's atmosphere, whilst speeding through and navigating myself through and from the sea of glass, and through the firmament of the heavenly skies, and breaking through the clouds to find my mother Mercidiah waiting unexpectedly for a sign if only to see me.

And so it was upon my arrival that I noticed her through an open window, as I loftily floated down and flew near to surprise her, and there as she turned to see me in the full splendor of my flight hovering and suspended in the air, she naturally smiled beautifully and was very glad and happily surprised to see me as she welcomed me in through the window, my son she said, which instantly brought me peace and pleasure to my heart, my son where have you been, I have been to place of unimaginable beauty and wonder mother, but look at you my son, you have changed, yes mother I have changed immensely, yes immensely you have, but tell me what news of Simeon have you brought me today.

My father is well I said, and he keeps his place evermore faithful within his pious nature serving and standing steadfast side by side with Hark the Herald Angel, as both of them are strong both in bond and of course in the union of serving the Elders who hold their position and authority in the first becoming of the several worlds, oh how I wish I could see them both she said, but you shall mother, one day you shall see them, but tell me how have you been Haven, it seems such a long time since I have seen you, if only to hear your voice and to remember your laughter.

I am very well and happy to see you, and as you know that your presence here fills me with such joy and gladness, but please continue to tell me more of this place that you have seen and been to Haven, as it give me such hope and pleasure and optimism to hear of such things, well Mother all I can really say is that it is a testament to be with you today and I also wish to explain to you that this is also a day of validation of both a marriage between what I can only begin to believe and express to you as something of a vow of renewal between my spirit and soul and also between the heavens and the earth.

Although to you Mother it may appear to be or seemly strike you as something more like a beautiful enchanting and harmless fairytale, but it is not mother, it is much more of an unwritten contract between mankind and the Angels of which I have mentioned to you already, but I pray not all is as it should or could be, as we are all upon reflection a part of each other's somewhat complex and infinite lives, and no one knows how much more, how this will can affect the balance and the equilibrium involving heaven and earth than you Mother, but what of your life here on earth is it not a lonely existence without Simeon being here with you.

Lonely, don't be silly, I am still very much an active woman in the prime of her life, and also in the pursuits of her interests and studies, and I am still very much engaged in the arts of mentoring to both young and potentially aspiring earth mothers, who are very much in need of tuition and guidance, but between you and me, both Kali Ma and I are both flourishing in our knowledge and spiritual gifts bestowed upon us from the blessings above, and so how can I be lonely when I have you to look forward to in my life, it is good news to hear you speak this way Mother, as it gives me great hope and courage where I once had none, but pray, I must tell you that my testament to you and also the inhabitants of earth is yet to be fulfilled, and that I only initially came here to see you out of worry and concern for your life, but now that I can see that you are happy and standing here before me, I too am also happy that everything in your life is progressing well for both you and Kali Ma.

Why do you worry yourself Haven, when you have nothing to fear, as I see that you are becoming a little bit more sentimental and a little more human every day, but as for these fears and doubts that haunt and bother you so much, I believe that they are just humane feelings and emotional attachments to things that you are still learning to accept and adjust too, but you must not let them hamper or distract you from whatever it is that you believe you must do, very well mother I understand and accept your critical and analytical observations of me upon this view but isn't being human the envy of every discerning Angel, I see you haven't lost your wit and your charm my son, yes I am learning that it is very human to make fun out of tragedy, of course but tell me what it is that you believe that you must now do, well I am not entirely sure, but it requires me to at least somehow fulfill my own salvation, especially in the future pertaining, but somehow my dreams do not always make sense or grant me with enough insight or wisdom or foresight as to how I must proceed to navigate myself toward it, as there are many conflicting elements that I believe are attached to the choices and decisions that I am now facing, and so for now I think, well I need just a human perspective on this matter, or even maybe just perhaps your point of view on this subject Mother.

My point of view, but how can this be of help to you in these arising matters, but they are of a great help to me mother, because even now as we speak to one another, I can at least deduce from my thinking, that what you are saying gives me the clarity that I need in order to gain a fair perspective on this matter, as there is something between here and there known only to those as the Qonshushmign's, and as I understand it, they are soon to awaken a reality with which without a doubt will have a consequential and conscious impact upon the face of the earth, as there are several strands of truth, to their influence and unpreventable dreaming, as there are also several variables or themes that can cast some light upon this life of constructed reality, and I may need your understanding to become aware of what this outcome or impact may likely turnout to be.

But Haven, how can I influence or help you to identify your role in the heavens, as this matter can only be your choice and decision alone as to what will or can occur next, as my only concern for you, is that once you have gathered your mind and thoughts together, that you have gained enough of an insight or understanding to choose and to command your acts wisely, but as an earth mother, I have very little influence over matters that are born or let alone arising in the heavens, no mother that is not entirely true, as you do have influence over me, as you are also the earthly consummate of my father Angel Simeon, and so what you do say does not only have an effect upon my thinking and what I choose to do, but also what your relationship means to me and my father in and amongst the first becoming of the several worlds.

As there is also something called the Emerald dream, something of which I am naturally a part of, and yet I have realized that there are many dreams which may have already become dreamt and fulfilled, and as of yet there are many more dreams still awaiting to become fulfilled, and yet I do not know how it can be fulfilled and sustained and carried out without my playing a significant part in its conception.

As the Qonshushmign's have always been and are also equally aware of the physical manifestation it will bring about as well as signify according to the will and the nature of its' composition, but surely my son it can only come into being through a transcendental means of constructive meditation, well yes that is also true, as I have also realized that in my being, that they or we or even I must somehow bring about an evolution of earthly creations, albeit through the nature of their own enlightened deliberations, and through our interactions here upon the face of the earth, but I also believe that it is also somehow because I have the ability to naturally influence the Empyreans and for this reason alone, it could mean or become the result of a spiritual war in the heavens if I am not able to find a point of universal resolve in this matter, as I am the last if not the least of the Angelhood who would and could account for this dream to become fully realized, and so they are waiting for you, yes they are waiting for me, then what will you do, I do not know the answer to that question yet Mother.

My son what I already know and have spoken of heaven will still always remain a mystery to me, and what I do not know I can only hope and wonder that it is somehow true to the dreams that have been granted and revealed to me as an earth mother and also as your Mother, and also as your father's consummate companion, but having said that, not every Angel can live up to the expectations and realizations that are deemed to be worthy enough to be given the honor and opportunity that I believe has been bestowed and extended to you, to bring both balance and harmony between the heavens and the earth, and yes it is also true to say that there has always been and probably always will be, another succession of Angels if not now then probably in the hereafter, and who knows how many more that have either been summonsed or have fallen or have even been sacrificed, or simply cast out, simply because they could or could not fulfill something of virtue, that was somehow bestowed upon their being, by being brought into life by the light of all eternity and creation.

Which as far as I know would be deemed necessary in order for both kingdoms of heaven and earth to stand, and so for now the representations of this kingdom that are somewhat troubling you with its' responsibility of burden, are being brought to bear upon your shoulders and it is just as relative to you in everything in the here and now, as to what it may also signify and mean to the future, but somehow your truth is being examined and called into question, as it is your truth that may resound throughout the Empyreans at this point in time with you at the centre of its' trial as either a witness or a deciding symbol, or as a token or gesture of the will that is to be pronounced, but I do not know perhaps in order for the venture of all other reasons of definitions and possibilities to come true, but why mother, why can this be the reason, well this must be the reason because I have named you Haven, but why mother, because you are and will always be my sanctuary, and no heaven can fail while there is a sanctuary amongst us here on earth.

But I so wanted to redeem myself mother by putting right the things which I thought should never have happened, or at least could have been changed or avoided or even prevented, but I understand now Mother that this is but one dream amongst many, and that I am simply one Angel within an assembly of legions who have either forged their alliances beneath the will of those that they have already gone out before me, or those who will go out after me, as there are also those who have chosen to remain in the Empyrean for whatever reasons beyond my own understanding, for their own and utmost duty and challenges, but as for that much I do not know, but what I do know, or have at least now come to terms with, is that there is no real choice or offer of redemption for me, for whatever I do has already been done, and who knows, maybe in some other unique way or context maybe even already have succeeded or surpassed itself in another form of fashion or conceivable way, which I might hasten to add, may already have dealt a deciding blow or at least contributed to a soon to become factor, and who knows maybe even have given way to my fate, or perhaps a scenario that could somehow thwart any misconceptions or misgivings surrounding my own undertaking and convictions.

Then listen to me carefully my beautiful child of heaven for the reckoning of the Qonshushmign's shall heed no more than this, for a soul cannot be traded for another soul, and a life cannot be bought or sold to replace the one with which came before or proceeded after it, and yet if life were something to be exchanged or given then inasmuch it can only be given as something that is either to be received or redeemed in part upon any acceptable terms of understanding, and such is the beauty of life and creation that the heaven have made it abundantly so, and so let them awaken to the realities that when they come forth to proclaim and to announce and issue forth their influence upon the world.

Then let them know that if it were not for the love song of the early morning bird, then no dawning could be any sweeter, or found to be any more true, or any more humble and obedient, than that which is of the cry of a new born baby calling out for some duly noted attention, whilst becoming immortally destined for the heavens to be, if only in order for us all to be remembered before we have all long been forgotten beneath the tree of life, and despite the elements that torment and plague us even whilst we are at play encircling the tree of life here upon the earth, then let it also be said that it is simply by the living of our lives, that what we shall wake up to find in the trials of our living, which is only for our faith if we are to be truly reminded of our former lives somewhere within this hierarchy of such high and low places.

As for everything else that is or ever was to be found in life or living in creation, still possess a soul and a determinate will and concern of its' own, and so whether we have the ability or the choice to choose or to accept its merits' or not, as even they in their unwittingly and superior knowledge that they possess which even the Qonshushmign's would seek to dictate and to imposingly implement and place their sanctions and their will upon the face of the world, then ask those who would call and recognize themselves as the dreamers of the Empyreans, who would wish and desire and to express and to exercise their own judgments and question of notoriety upon or over the face of the earth, that inasmuch that their dreams however dreamt and however expressed, and of whatever little significance and meaning and bearing shall also be felt and be brought to bear upon us all.

And then we shall see if this decree is somehow destined to reach us all across the width and the breadth of the heavens and the earth, in its' preparedness to touch every living soul along the way, and then we shall see what forces of nature shall be made to be laid to bear upon us all as ordinary beings, and as for those of us who are even ever more ready to be made worthy of the light of creation throughout all eternity, then tell that to the Qonshushmign's in their awakening, now go before I lose my strength or keep you from your place in the skies above.

But mother, no buts Haven I shall think of you always, even until such a time that all things are complete and made anew, now go. And whatever happens my son, you are the chosen one, and whatever you choose to do, is only because you have become selected and appointed as the delegate of the Emerald dream, and soon upon your return to the Empyreans, they shall look upon you as the ambassador of the earthly Angels that also live and inhabit and reside alongside you but be warned, as only the origins of the natural hierarchy of the Empyreans will try to discredit you, and look upon you and treat you as if you were something different or anything less credible than themselves, as they may even attempt to hold you in contempt as with a regards to deem you unfit or unworthy to be given or granted the title and the name that you shall now come to bear.

But if you demonstrate great wisdom and show good diplomacy in their eyes, then they will not try to defeat you in your trial, as none of them can interfere with the natural order of the things that have already been written or come to pass as proclaimed in the heavens, but if you choose otherwise then you know what your fate and outcome shall be, for it has already been written along with own your helping hand and because you have said as much, then it shall come to pass and justly so, yes mother I understand it, for I know what I have already said and also what I did not say, and I am also aware what I meant to say given the reality that has now been presented to me, but never would I have imagined or believed in a thousand eternities that so much emphasis would be put upon how I would choose to conduct myself within these realms and beyond.

Yes Haven I'm afraid it must be so, as much as I know that it must
be very difficult and hard for you to accept, and to imagine so much
in such a little and short space of time, but you are an Angel, and
in being so, you shall come to learn and to respect that it is only by
being human, that we can afford to be forgiven for our own choices
and action of words with which we cause ourselves to be so careless
and frivolous with as well as our expressions of free will, which in
itself is a reckoning of our own loyalty and obedience to the truth,
but you must obey and come to rely on and know your true Angelic
nature Haven, for its' importance is something to be adhered too, both
as a means of conduct and formality, if you are to truly succeed in this
dream, but this dream seems to hold me captive mother, no Haven I
dare say it does not, as it is this dream that shall eventually lead you
to your victory and salvation.

And so as I left planet earth, indeed it seemed even harder for me to
escape and to feel completely free from the pull of earth's gravity,
pulling me down even further into the depths of my own sorrowful
soul that was now being born in the words of Mothers tears, but as I
left I was not so sure if indeed this was the beginning of something
new or even perhaps if this were the end of something, or even
whether it was the first time I would have seen my Mother as Zyxven,
or indeed whether it was the last time that I would have come to visit
her as Haven, and so onwards with the echo of her voice ringing in
my ears and resounding in my heart, with the choice of my decisions
now lingering in my mind, as the only real consequence of my
comfort was knowing and believing that not only did my Mother truly
recognize and know me as I was, even if I did not know who I was
myself.

And so during my flight of reconciliation and rediscovery, I did somehow perceive and pursue to take note of the idea that there were no separate parallels or true notable distinctions between heaven and earth, as everything that my mother had mentioned, seem to be true in saying that everything was in accordance with itself, and as her words of wisdom resounded and echoed around me silently while sanitizing and influencing the love that would eventually come to wipe away my tears and the shadows that once engulfed me, and prohibited me from reaching the places in my heart that only she could reach and touch inside my solitary flight back to the Empyreans.

And who's to say that what I am to be presented with whilst heading toward the truth of my own future and destiny, which was by chance somehow in some way written in time, or in a future that I had once witnessed and become subject too, or as in turn it was also ultimately heading towards me, and the fact that these rumors suggesting that the tree of life was, or had somehow become defeated by time, and could also suggest that the remaining Angels of the Empyreans had somehow come to be divided by those of us who would seek to uphold the balance of the heavens, against those of us who would otherwise become the opposing harbinger's with the thoughts and the ideas of revolt now seeking to tear it down, and so my loyalty to the Qonshushmign's and their dreaming is perhaps by now calling my actions into question as to whatever they had also acquired to learn of my future life and fate, which I believe would also give them the insight and the upper hand with which to be determinate as to whether my decision to act accordingly to this will was forever progressive with their present and current truth.

But if the Empyreans were divided then surely the heavens would fall and the earth would become cut off from the tree of life, and yes indeed the skies would fall and shake and rumble, and all could be lost if I Haven did not possess or did not have or even hold the key to this deciding answer of fate to a question that could hold enough clarity to keep them all at bay and satisfied beyond this apocalyptic event pertaining, and so who is with me and who is against me in this choice of action that they would choose to address or dream of another dream, or indeed find favor in another reality if not mine, as if in my own knowledge and realizing that a heaven divided cannot be permitted to draw conclusions and stand, and so in my infinite will, it shall be Zyxven who must stand or even fall from such a mighty and magnanimous height, that even he would bring down all that had sought to disrupt and to corrupt my heart and mind by bringing me into contention with the world that I have come to love.

And such was the mastery of their forth coming proxy, that in being and becoming this anomaly and the singularity brought to question with, was I now to come face to face with a multitude of Angels amidst the Elders, who would perform and organize themselves as the elect and the elite order of the Qonshushmign's, or as the immediate counsel who would hear and receive my account and testimony, if only to satisfy their own incompatible knowledge and experience of ideas, with a view to take the strands of power and authority into their own perfect and embellishing dreams with a remit as to how we the last few remaining earth Angels of the Empyreans should be instructed and governed according to our heavenly union with the earth and its inhabiting occupants, knowing full well that my revelation could or may somehow hinder or influence or tip the scales of justice or universal power for all concerned, either to the left or the right hand of the Almighty one, and of course the one of whom we have all been called to serve, as a witness, or as a beacon of life or hope, or even as a sign to be recognized and welcomed into this the sight of his saving grace.

And so it began as it had proceeded, as I was to now address the assembly with no defense or representation before me, and as I looked round and about me, I stood firm and spoke confidently in saying, for my silence and for my faith, and for my loyalty and for my life, as even you who have brought me here to put me on trial, have also called yourselves into question, and yet we have recognized ourselves together as the household of heaven, and yet we have also examined the past to make perfections out of restorations, in knowing that the earth will gravitate towards the ultimate, a truth that is revealed to us here in this aeon, according to I Angel, and also to you who require that the Emerald dream is to be, and is to become fulfilled.

But if we fail in our dreaming, then ultimately the earth shall be the first casualty of this failing and suffering, and yet if we succeed then the earth shall be championed once again, and may be permitted to keep its' natural place within and amongst the natural stars and the tree of life now found to be sustaining us through these heavens prevailing, and so I say whatever is written, then let it also be written upon the face of the earth, for I have already found out and discovered much to my dismay and disappointment, a divided heaven, where we all fall from grace from time to time and time again, but as for those of us who should choose to turn away from creation, have already begun by dispelling and expelling the earth from their hearts and minds, and yet as for those of us who can create nothing more precious within this union, then let them become human in their endeavors to question the many meanings and interpretations that are now to be found and uncovered surrounding this creation, and as for those of us who endeavor to dream beyond this realm of wonder and glorious amazement, then let him also influence the counsel and be granted the tongue to guide and to give wisdom and instruction to the Qonshushmign's and their lingering vision dream of the Emerald dream.

As it is with each new passing phase of this aeon, that it has also become written and proclaimed, that a new Angel shall awaken if not to dream of the Emerald dream, then let him dream of another dream, for all eternity is quietly watching, whilst we in our preparedness are being called into question as to how we should and could perfect ourselves in our conduct, as well as restore ourselves back to the glory of the Almighty one, if only to learn once again how to speak the exalted name in such a way so as not to cause the heavens to cease, or to be abandoned, or to be left alone, or to begin another day without our promise and support behind it, as it is also written in this the event of my awakening and my testament and testimony, that I should put it to all of you to answer this one simple question, of how we the Angels of the Empyreans could become such opinionated and opposing adversaries, coupled with the fact that we in our own authority could manage to bear such contempt and arrogance, along with the vice of such abstracted and distorted views of interest, of how we who could be filled with the holy spirit of hosts, that we could somehow contain the very idea or notion that such an enormity of detached, and distracting, and fractured views are even acceptable to this the household of heaven, when we should in fact continue to uphold the very sanctity of the Empyreans and the eternal significance of the tree of life.

Especially in knowing that in this consequential event, that has now led us all to believe and to pursue this fragile idea and notion, that each and every one of us can stand alone and independently of each other, or even indeed that we can each pick or choose a different path or view, which can only be of an influence and a design filled only with the primal power of an instinct which can only be conceived of a nature to destabilize and to separate each and every one of us from the will of the other.

When all we truly are, or ever were, are merely the celestial embodiment and heavenly members of this the Empyreans who now dwell amongst those that would call and recognize themselves as the Elders of the first becoming of the several worlds, who I might hasten to add are soon to summon me there as we are all to be gathered together to currently preside and to define over our roots as Angels within these infinite realms, in a place where all our destinies and dreams are so intrinsic to one another, and where I must also declare and reestablish in saying and reminding you all, that we are all simply merely constituent parts and extensions of one above the other.

And so if I am called into your service by your acts, or indeed by the deeds that I myself have committed, and if I am then to be found unworthy in your sights, then let me set an example for each and every one of you by paying for that penance through the corrections or any reforms that are necessary to be addressed or to be administered or applied to me in any way fit for an earth Angel, if only in order for my wings to be deemed with the remission and the worthiness so as to remove the blame and the stains that I may bear upon me, so that I may also in turn be forgiven and restored up to my proper place of service and duty, and so that I may demonstrate and uphold the innocence and the integrity of my will, so that all that is in me can also be seen as an object of purity and light shining as brightly as snow in order for me to fall and stand in line amongst you.

And just as I had spoken it to the multitude, and of those who would now become the Qonshushmign's, who did indeed open up through their rankings with a legion of Angels standing on either side as equals, did indeed part the ways so as to allow me to make my way, and my entrance directly through to the extended passageways that would eventually open up and lead me into the first becoming of the several worlds, and whilst they would in turn watch and wait whilst this recess took place in my presence, in order for them to present to me the judgment and the destiny of my fate, and indeed as I arrived there in the place where I had once been too by the element of chance, or indeed misadventure through my journey's escapade, it seemed only befitting to me that I had now been summoned once again to the first becoming of the several worlds, except that this time it was upon their instruction and demand, and the fact that it was Hark the Herald Angel who would first approach me and to present to me the final and closing statement within this epic arena of an unfolding drama simply by saying.

Haven, Angel Haven, yes, yes, yes, For your silence, and for your faith, and for your loyalty, and for your life, yes you have been of much concern to me and your father and the Elders of this realm, but you have fought with pride and with conviction not only to defend its' principles, and to discipline and to master your own fate, and much to our surprise and of course your detriment, and the subjection of your own inner spirit, of both this and the other world, much with which we have come to understand that even ye also love but remain a stranger too, that I too must also now disclose to you, that I too also have a will, and a compassion, and a commitment to uphold the heavens concerning the earth and our relationship to it.

And had you not chosen to defend it, I too would have fallen out of favor with the hosts of heaven, as I too Hark the Herald Angel, would also be made to be silenced, and also be made to be prepared to sing of it no more, and so you have proven and demonstrated above all else, and to all the earth Angels of the Empyreans especially, as well as the Qonshushmign's, that some things upon the earth are of such a value that they simply must be defended, and guarded, and inspired, and loved, and appreciated, and protected against, despite whatever happens or takes place here within the Empyreans and in and amongst our fellow servants of the first becoming of the several worlds.

And so it shall be that your father Angel Simeon and not I who must ultimately take the decision and grant you with the exemplary opportunity if he so chooses to do concerning you his celestial son and if you Haven are to be found worthy or unworthy to be chosen or duly elected to be amongst those who are destined for a place where the Emerald dream begins and never ends, as it is a dream which is now to be dreamt of that and that in which the Angelhood has been created and designed for, as there is no other heavenly realm that could notably be achieved without this new succession and turn of events, which is yet to set the foundation of those that shall come after you, and also concerning those things that are also about to be put in place.

And so as my father drew near to me and approached me in the open court of the several worlds with all eyes to see, and to record, and to witness this event, and my trial with the Empyreans behind me, and there before me as the Qonshushmign's looked on, he began by embracing me and then looked deeply into my eyes saying, my son, my celestial Angelic son, my Haven, my future, and my destiny, is it not written in your heart, and have you not witnessed it with your own eyes, that what is also written in the heavens, is also written upon the earth which was also once divided, insomuch so that many of my fellow friends and servants who were also sacrificed in the warring realms and the dwelling place that we have also come to know of as sheol.

For nothing more and nothing less than what is required of you has been presented to us in this aeon, and in by their doing so, did their loyalty indeed give way and support, and provide a solidarity between the heavens and the earth once again, and also in their sacrifices, did they also be given a promise and a declaration, that they too would also be lifted up in the last days of the earth, and resurrected unto a new dawn and unto a new era in the event of this history, and so I say to you now that if heaven is to be brought down to bear upon us once again and upon the earth because we in ourselves would dispute the authority, or the very creation of both the heavens and the earth below, then so begins another harvest and many more will still be sacrificed for the sake of it, or indeed for something more precious.

But if you choose to accept that everything is already in accordance with itself, and that whatever or however we perceive this indivisible matter of their world and ours, insomuch so that we should take matters into our own hands, then we are no better a fulfillment and a promise than those who would seek to end this creation altogether, so even as you have come to know, and come to learn that the future can easily become changed at will, and in by doing so, it is now only your choice alone, if you choose to reside within your sanctum and chamber amongst the Empyreans as you once were.

Or if indeed you choose to go to the far ends of creation for the answers that you now seek, or rather, that you have now somehow come to realize, and to choose, and to yield, and to learn, and to accept, and to take some peace and comfort and refuge in knowing that heaven is, and has always been within us all from the very beginning, and so I strongly urge you to think and to consider all of this in your infinite knowledge and wisdom my son.

And with that plea and statement he placed a book within my hands as well as presented me with a veil that was now to be placed and tied over my face, and once this act had been performed and carried out, there in the open court, everything and everyone became still, as the air fell silent round and about me, but that was just for a short moment in time, until a slight murmuring of sound began to stir up from the Angels and the onlookers of the open court, who had now surrounded me on all sides, and such was their observational silence, which was by now to become broken, as they unanimously began chanting the name Zyxven, Zyxven, Zyxven over and over again, until it seemed to echo throughout the open court whilst entering into my ears and drowning out the thoughts in my mind, and becoming infinitely louder and louder, whilst increasingly growing in volume and intensity with each new passing phrase of breadth and depth of conviction with which it was intended, Zyxven, Zyxven, Zyxven.

REFERENCE

~*~

Empyrean—(Heaven/Angelic Dwelling Place)
Haven—(Hope)
Hark the Herald—(The Listening Angel)
Simeon—(The Protecting Angel)
Selah—(Earth Mother)
Kali Me—(Earth Mother)
Mercidiah—(Earth Mother)
Qonshushmigns—Conscious Minds/Truth/ Reality
Nejeru—(New Jerusalem)
Sea Of Glass—(Revelation 4)
Several Worlds—Future Event
Zyxven—(Agreement/Covenant/Spirit)

~*~

~*~

According to the devout and historical scriptures, it is only on occasion, that only a select few amongst the worthy and the chosen, have become allowed and permitted to see the persona and the indistinguishable personal face of God, albeit less in person, and albeit more than frequently in dreams and visions, but above all, God has always mediated and relayed this message of his infinite unimaginable realm and Kingdom, not only through the counsel of his Angels, but also through the prophetic words and knowledge and wisdom, which were and have also become translated through the mediums of Man, and Child and Woman alike, albeit that the signs and wonders of the times are somewhat born out of an unusual means of unpredictable and sometimes miraculous random acts and happenings, that can only truly be realized to reconcile us back to the faithful once we have momentarily become returned to the world and focused upon its' and our entirety as a whole, and so what chance do we as mere mortals of flesh, blood and bone have in experiencing and witnessing this God, except that in our faith and hope and love and trust, that we too shall learn of God's true nature and intended purpose in our lives, even if indeed his Majesty's revelation is forever veiled and remains hidden and is less than obvious in its' revealing and teaching to us. Well I simply say and believe that it is upon this premise that when we choose and decide to take upon ourselves the onus of our own personal authority upon this Earthly domain, with both just and personal and fair regard to the responsibility of each other and towards our humanity, is simply to declare in this belief and understanding and acceptance, that now is the Kingdom of Heaven, and that now we must affirm our personal faith and knowledge and assurances, comprehending forthwith, that in our completeness and fulfillment that in our satisfaction and contentment, that God will be, and has always been with us from the very beginning of our eventful existence.

~*~

FINALE
Angelus Domini

A **Tao.House** Product /**AngelBabies**

INSPIRIT*ASPIRE*ESPRIT*INSPIRE

Valentine Fountain of Love Ministry

Info contact: <u>*tao.house@live.co.uk*</u>

~*~